This book brings together two visionary works of art: James Ensor's masterpiece, CHRIST'S ENTRY INTO BRUSSELS IN 1889, painted in 1888 and now in the Getty Museum, and Bob Dylan's "Desolation Row," from his HIGHWAY 61 REVISITED album of 1965.

With the details we've selected, we invite readers to take an extraordinarily close look at Ensor's colossal work. But we also hope readers will be led to meditate on the modern fears, predicaments, and obsessions that Ensor's great painting embodies and that, seventy-five years later, a young singer-songwriter sardonically set forth in his depiction of a depleted yet strangely vital place he called "Desolation Row."

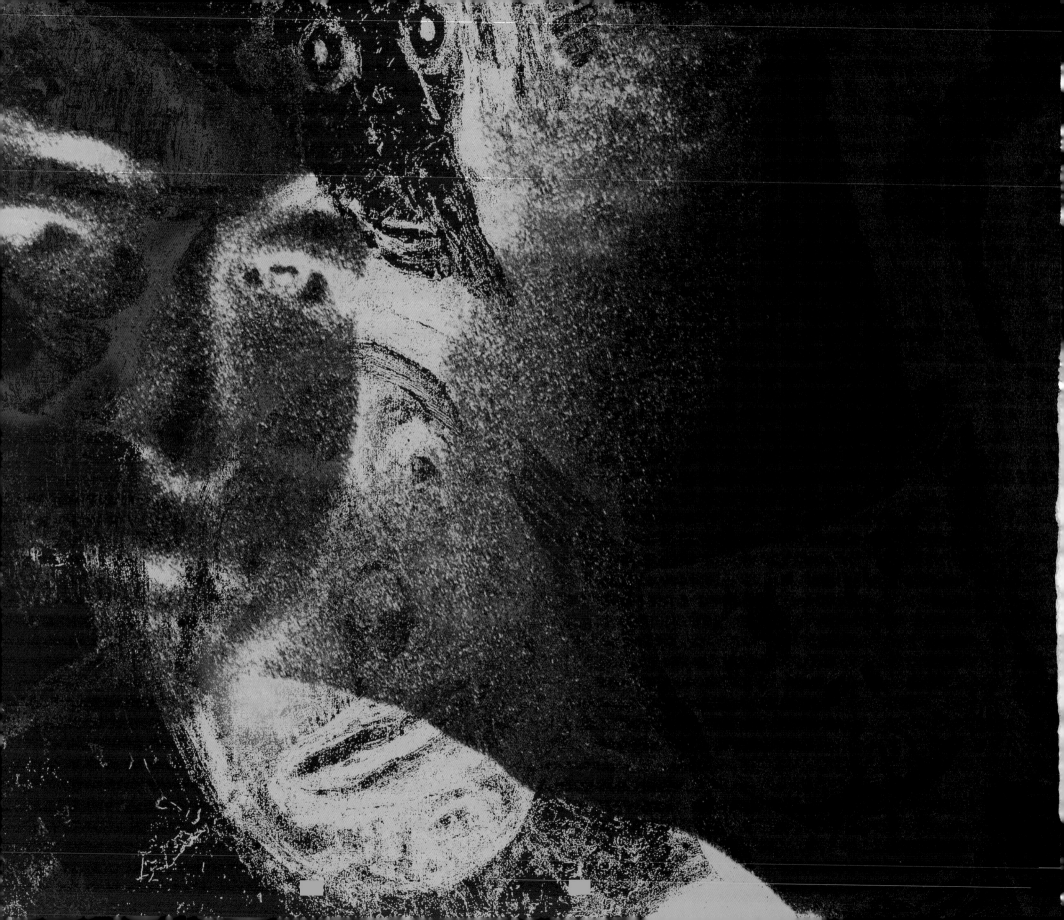

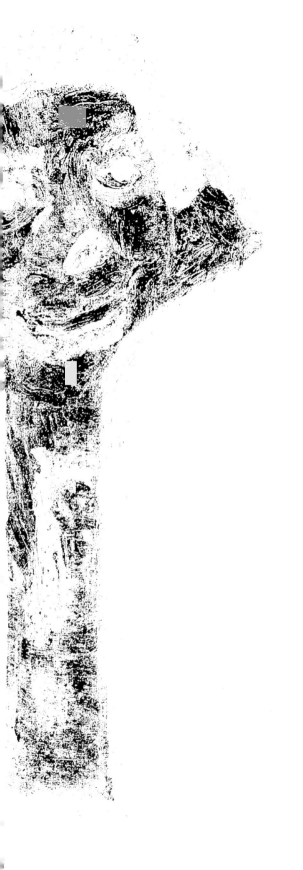

the SUPERHUMAN CREW

Painting by James Ensor

Lyric by Bob Dylan

Edited by John Harris / Designed by Markus Brilling

The J. Paul Getty Museum, Los Angeles

They're selling postcards of the
They're painting the passports
The beauty parlor is filled wit

hanging

rown

sailors

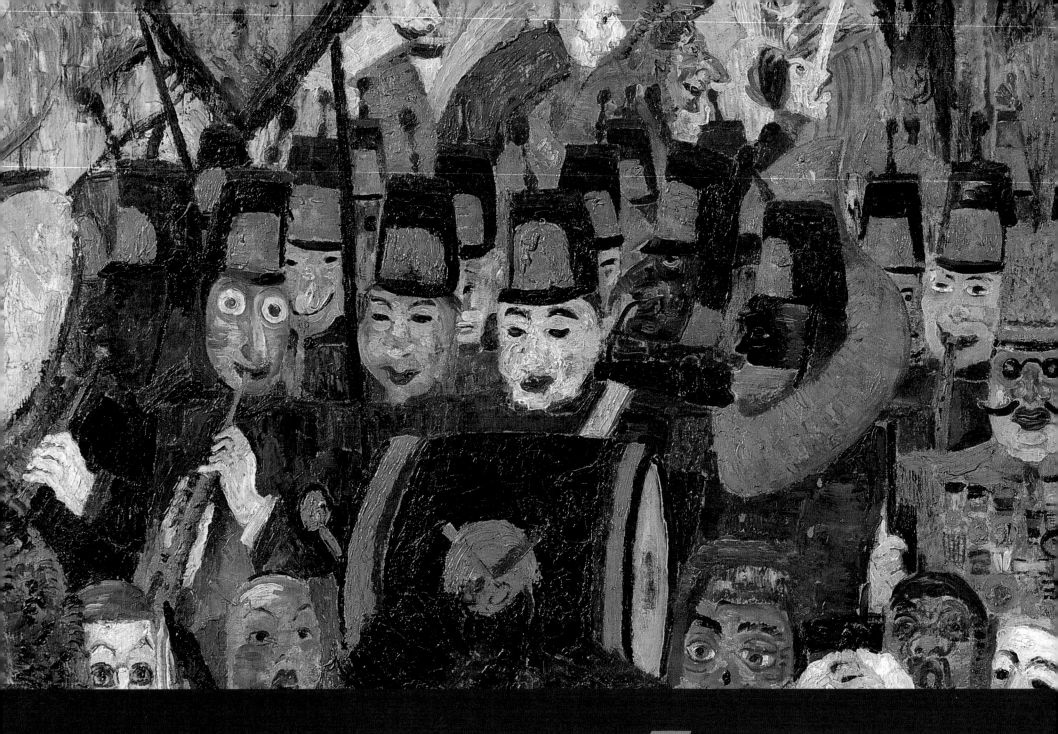

The circus

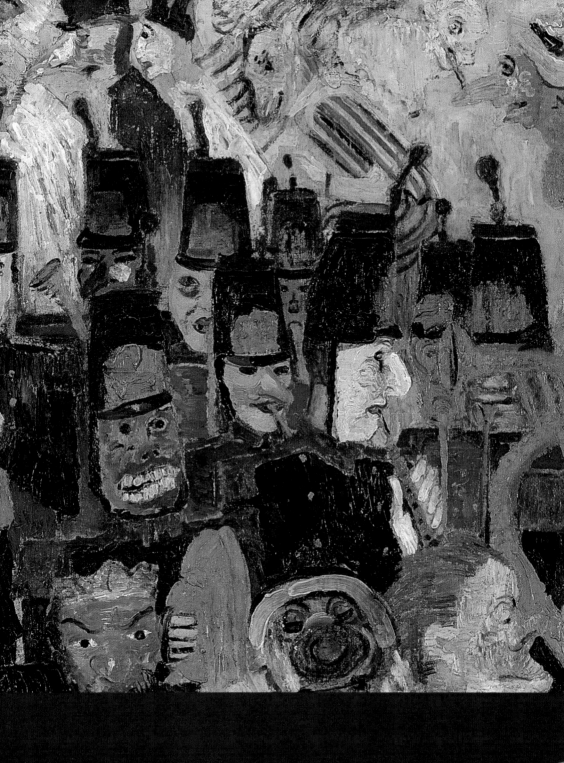
s in town

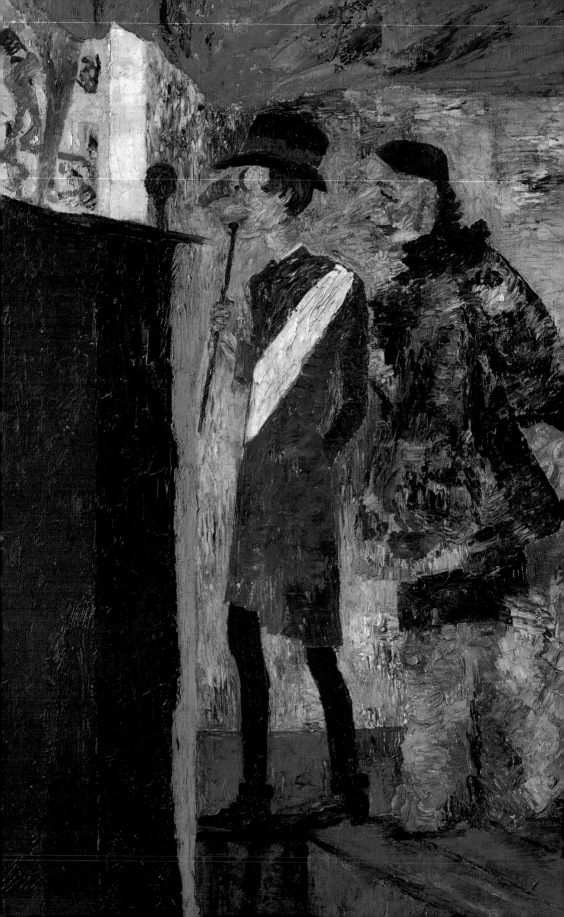

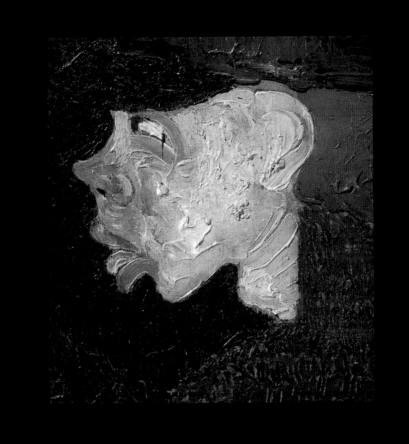

Here comes the blind commissioner
They've got him in a trance
One hand is tied to the tight-rope walker
The other is in his pants

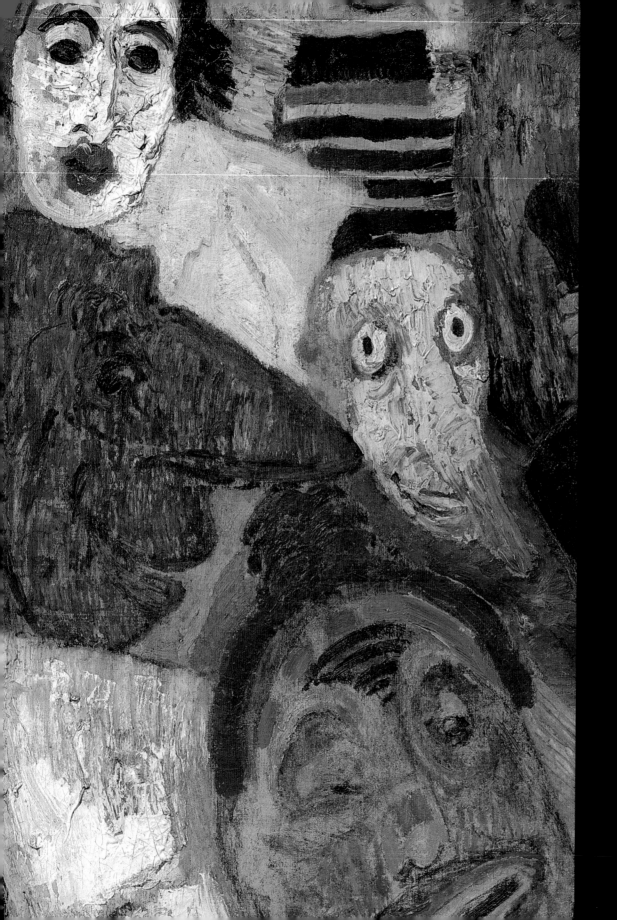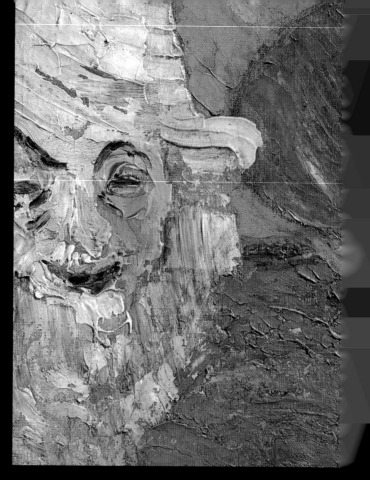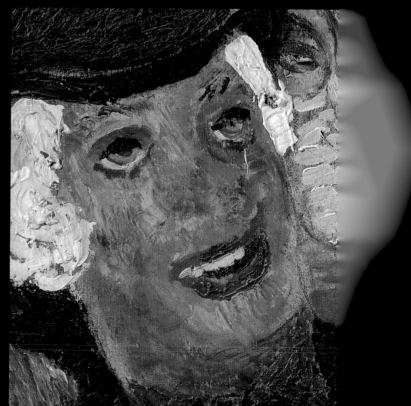

And the riot squad they're restless
They need somewhere to go
As Lady and I look out tonight
From Desolation Row

Cinderella, she seems so easy
"It takes one to know one," she smiles
And puts her hands in her back pockets
Bette Davis style
And in comes Romeo, he's moaning
"You Belong to Me I Believe"
And someone says, "You're in the wrong place, my friend
You better leave"
And the only sound that's left
After the ambulances go
Is Cinderella sweeping up
On Desolation Row

Now the moon is almost hidden
The stars are beginning to hide
The fortunetelling lady
Has even taken all her things inside
All except for Cain and Abel
And the hunchback of Notre Dame
Everybody is making love
Or else expecting rain
And the Good Samaritan, he's dressing
He's getting ready for the show
He's going to the carnival tonight
On Desolation Row

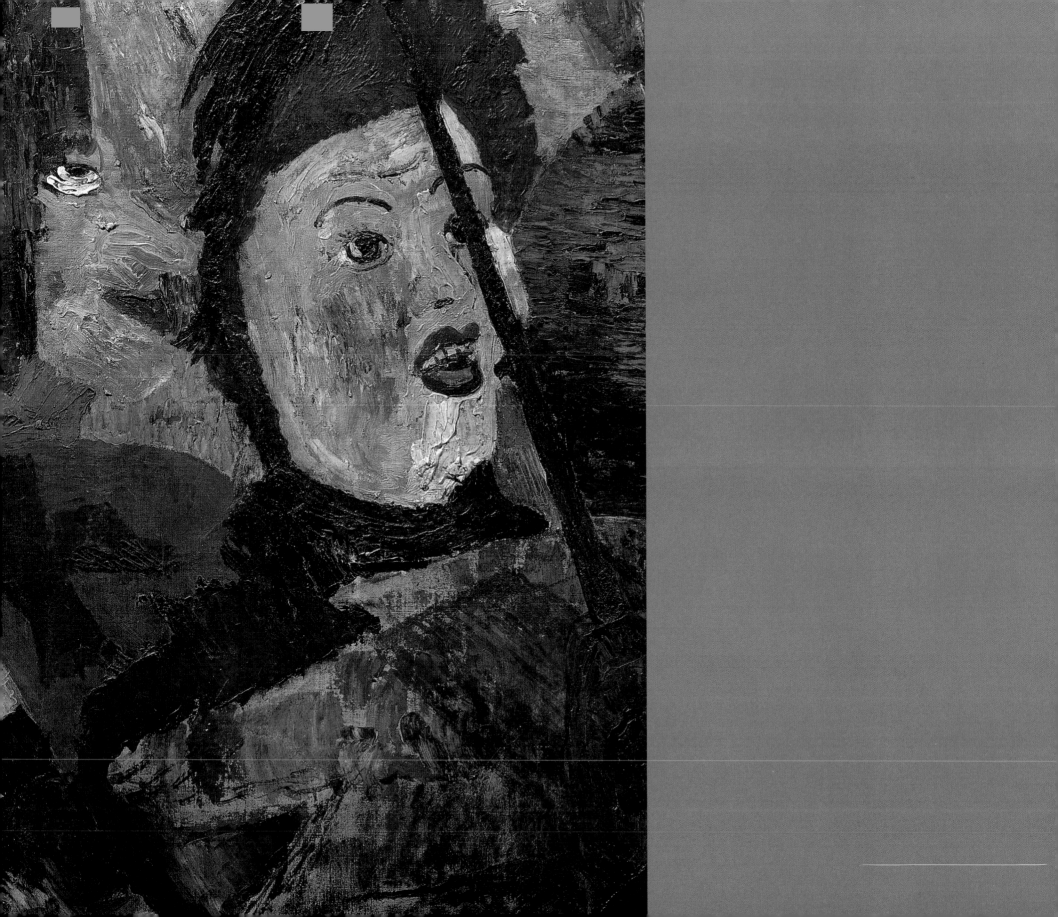

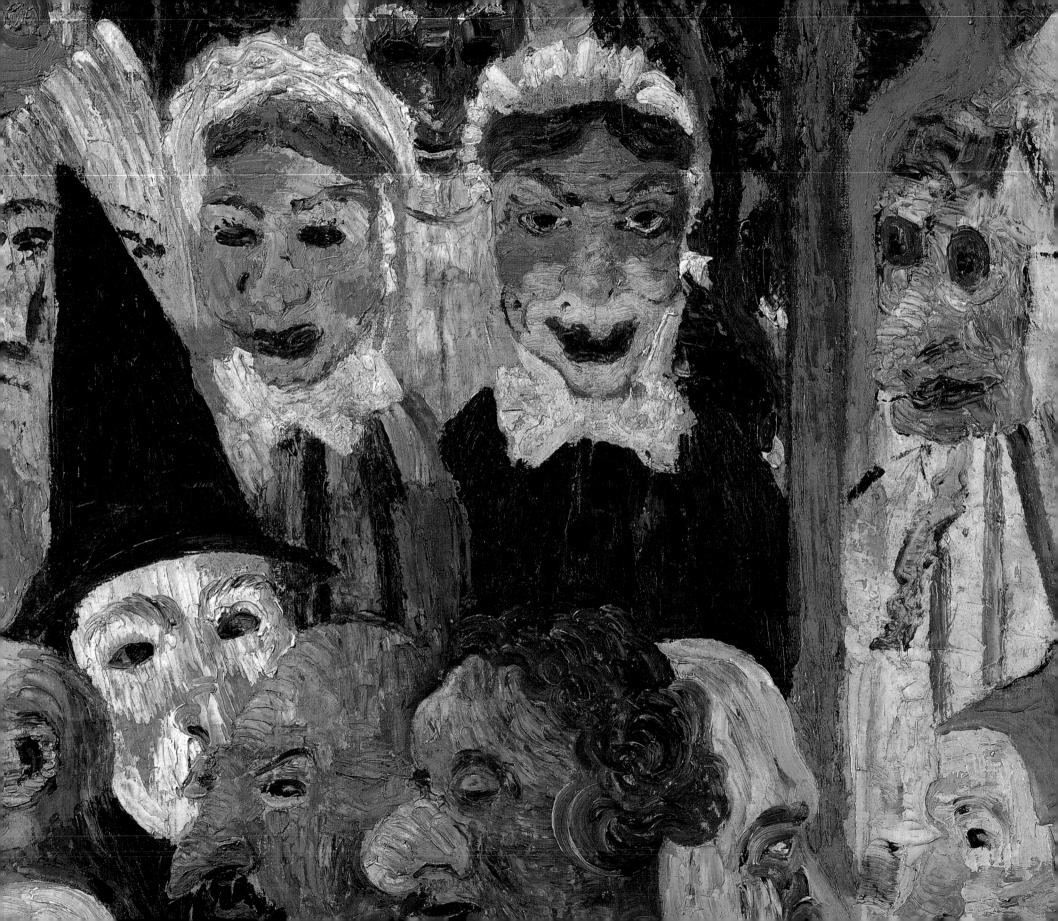

Now Ophelia, she's 'neath the window
For her I feel so afraid
On her twenty-second birthday
She already is an old maid
To her, death is quite romantic
She wears an iron vest
Her profession's her religion
Her sin is her lifelessness
And though her eyes are fixed upon
Noah's great rainbow
She spends her time peeking
Into Desolation Row

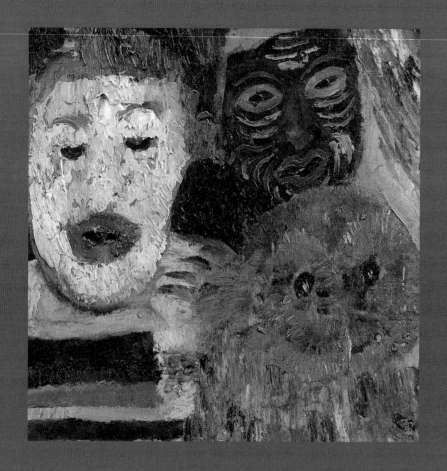

Einstein, disguised as Robin Hood
With his memories in a trunk
Passed this way an hour ago
With his friend, a jealous monk
He looked so immaculately frightful
As he bummed a cigarette
Then he went off sniffing drainpipes
And reciting the alphabet
You would not think to look at him
But he was famous long ago
For playing the electric violin
On Desolation Row

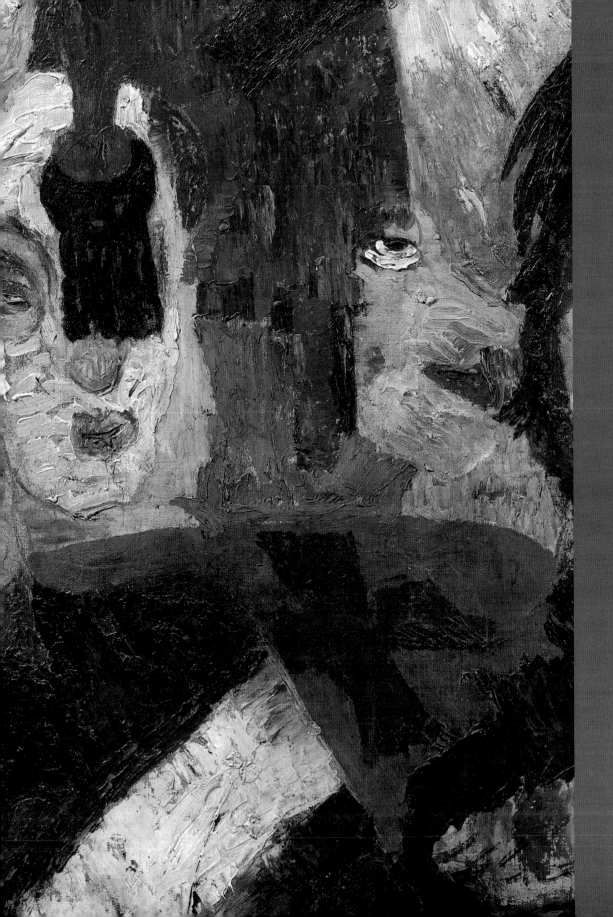
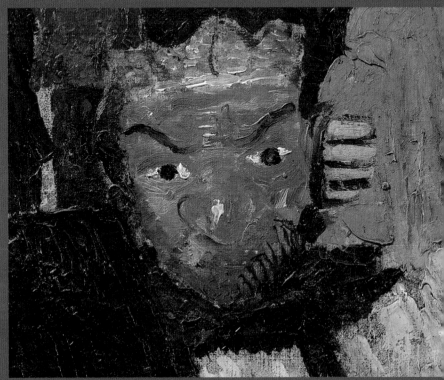

Dr. Filth, he keeps his world
Inside of a leather cup
But all his sexless patients
They're trying to blow it up
Now his nurse, some local loser
She's in charge of the cyanide hole
And she also keeps the cards that read
"Have Mercy on His Soul"
They all play on penny whistles
You can hear them blow
If you lean your head out far enough
From Desolation Row

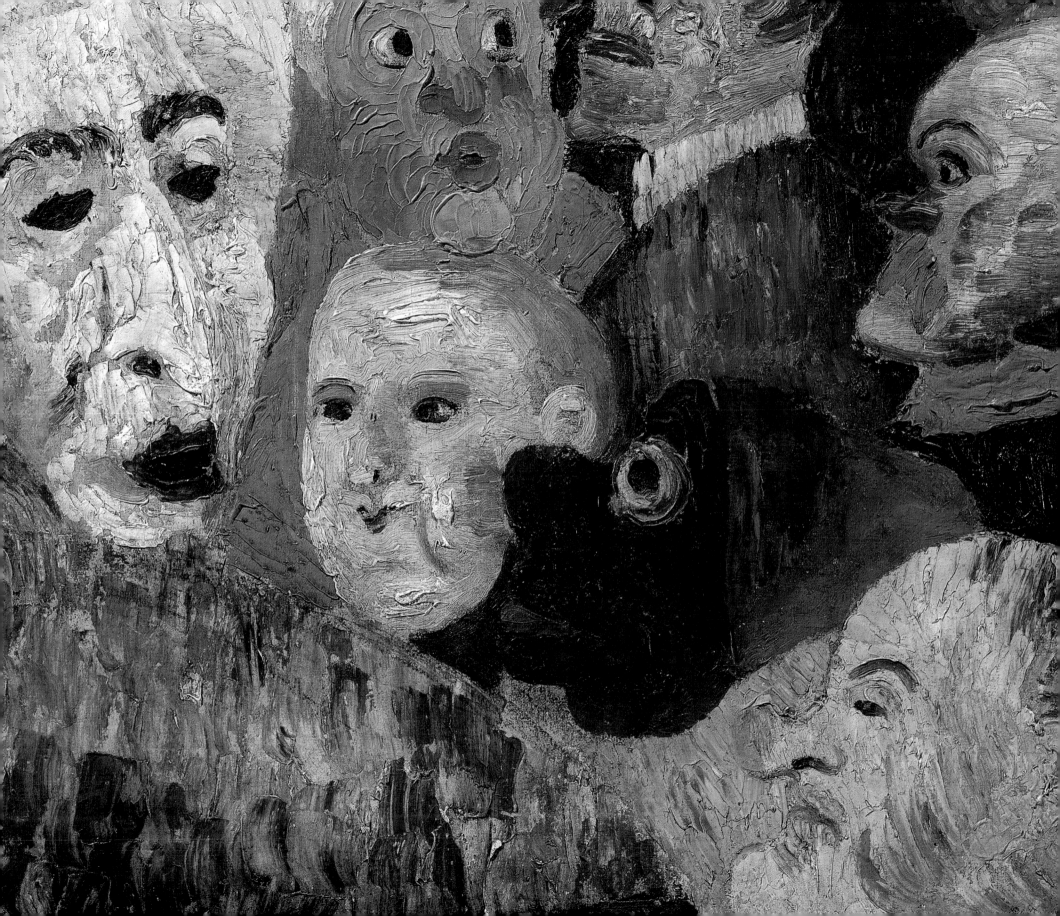

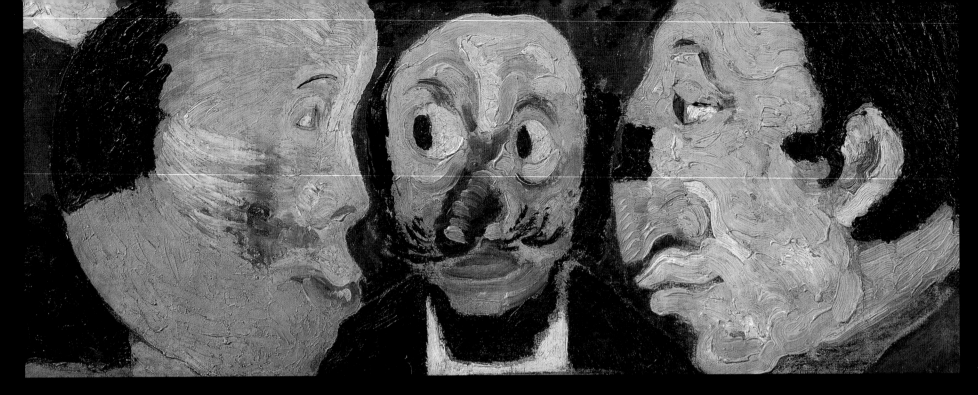

Across the street they've nailed the curtains
They're getting ready for the feast
The Phantom of the Opera
A perfect image of a priest
They're spoonfeeding Casanova
To get him to feel more assured
Then they'll kill him with self-confidence
After poisoning him with words
And the Phantom's shouting to skinny girls:
"Get Outa Here If You Don't Know
Casanova is just being punished for going
To Desolation Row"

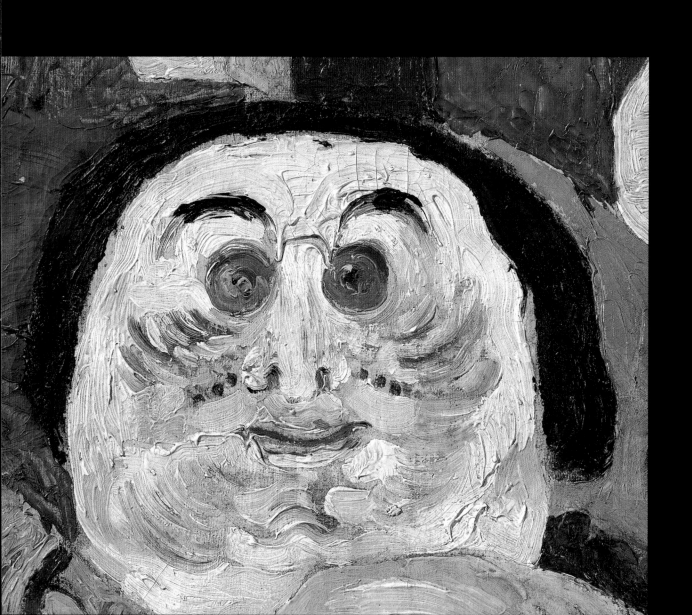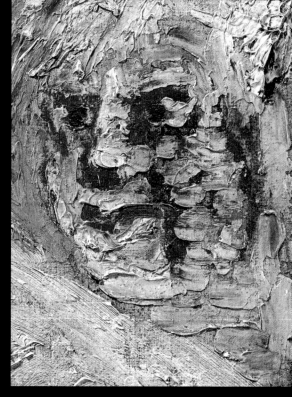

Now at midnight all the agents
And the superhuman crew
Come out and round up everyone
That knows more than they do

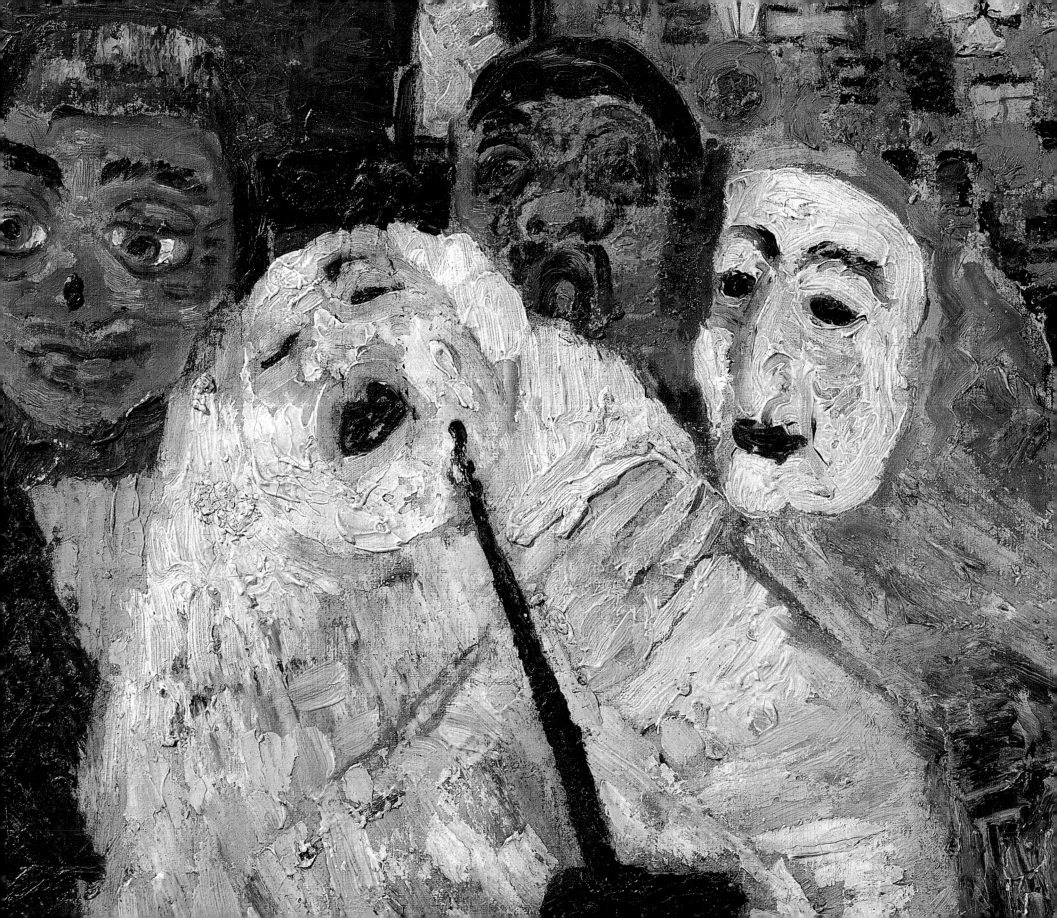

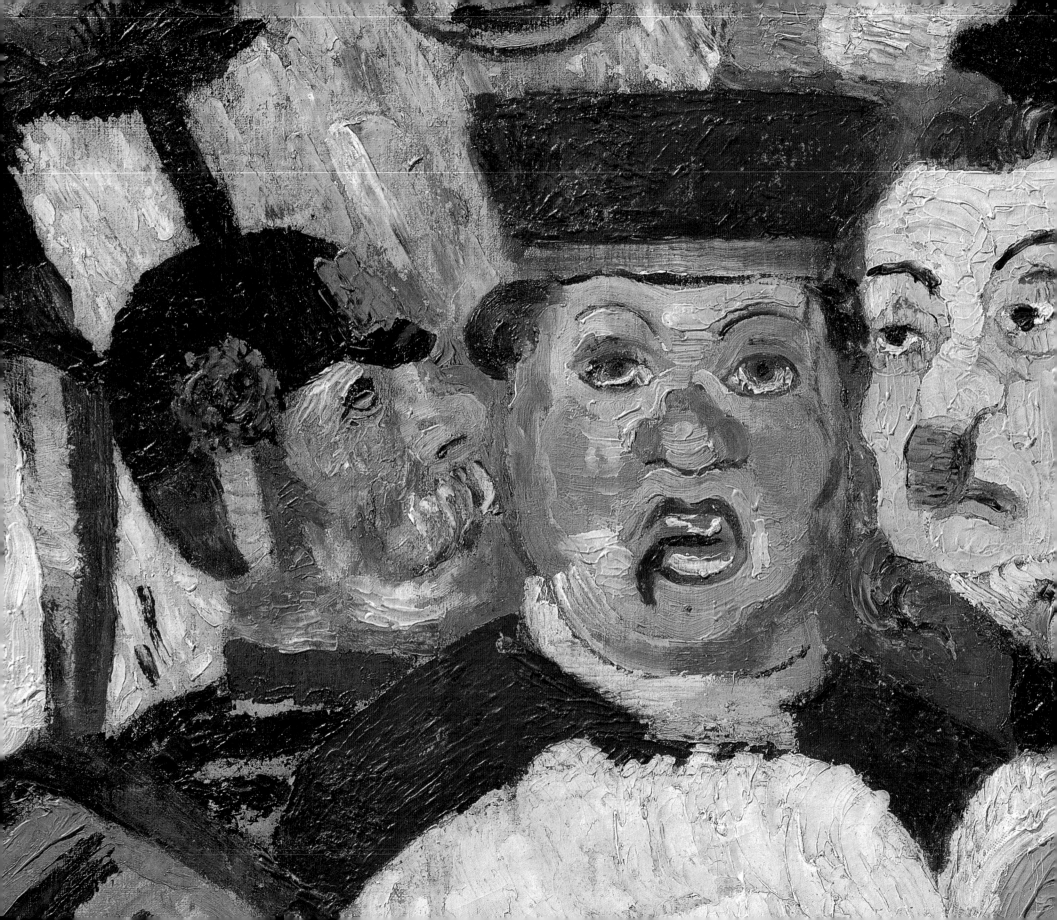

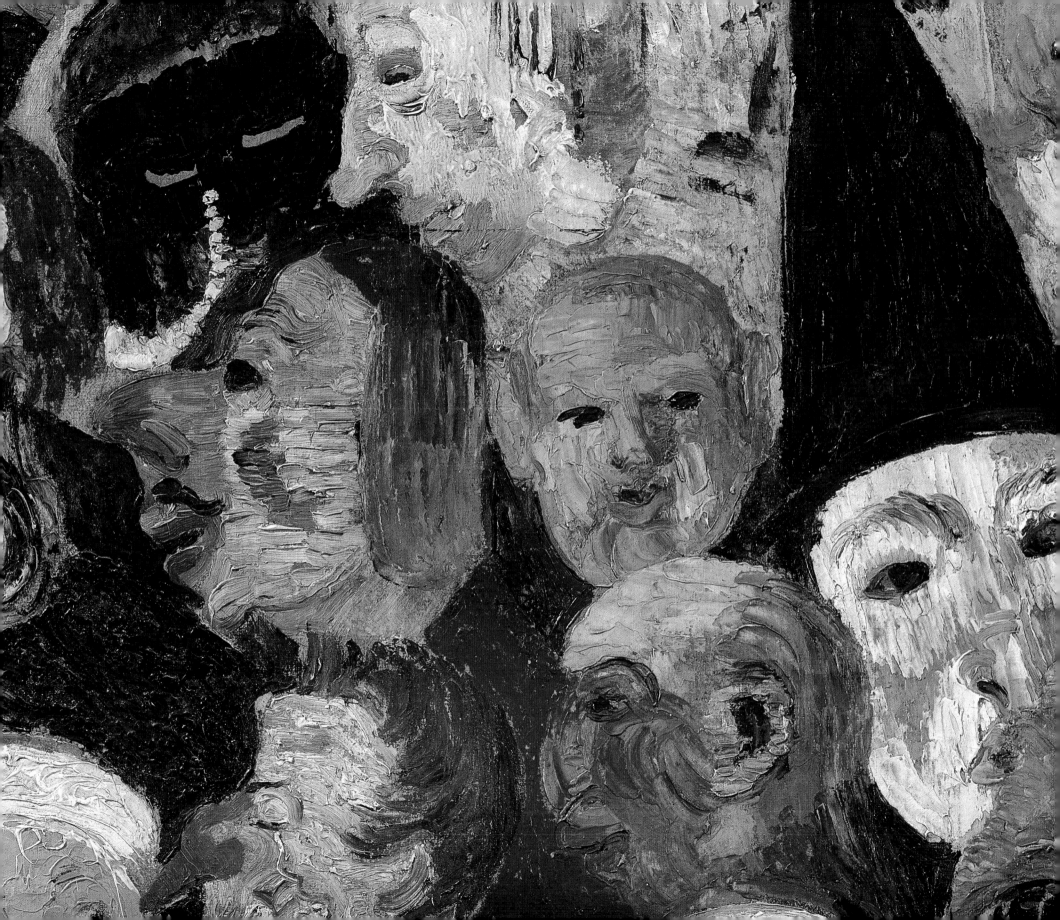

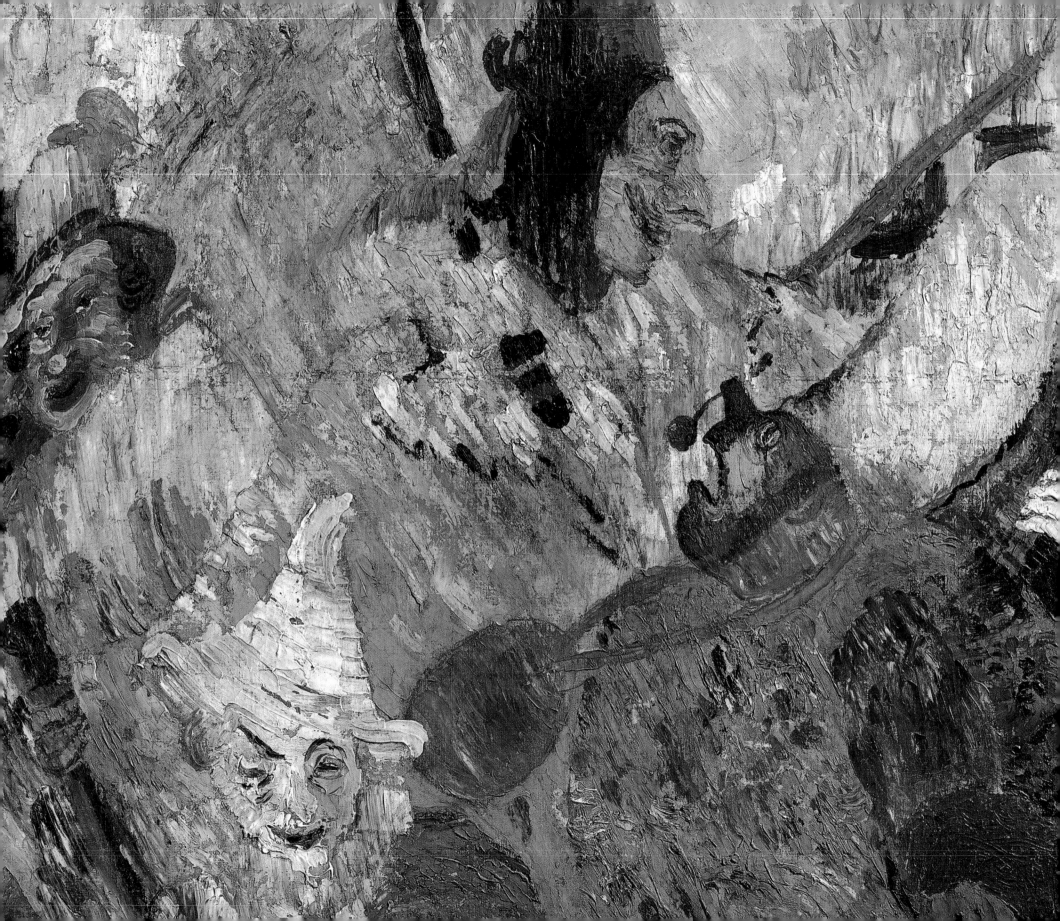

 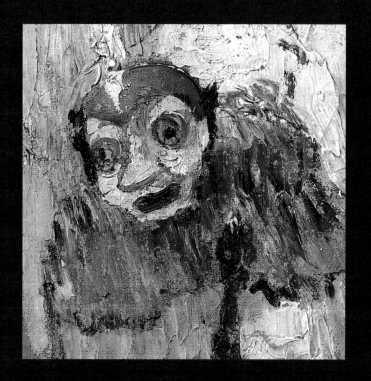

Then they bring them to the factory
Where the heart-attack machine
Is strapped across their shoulders
And then the kerosene
Is brought down from the castles
By insurance men who go
Check to see that nobody is escaping
To Desolation Row

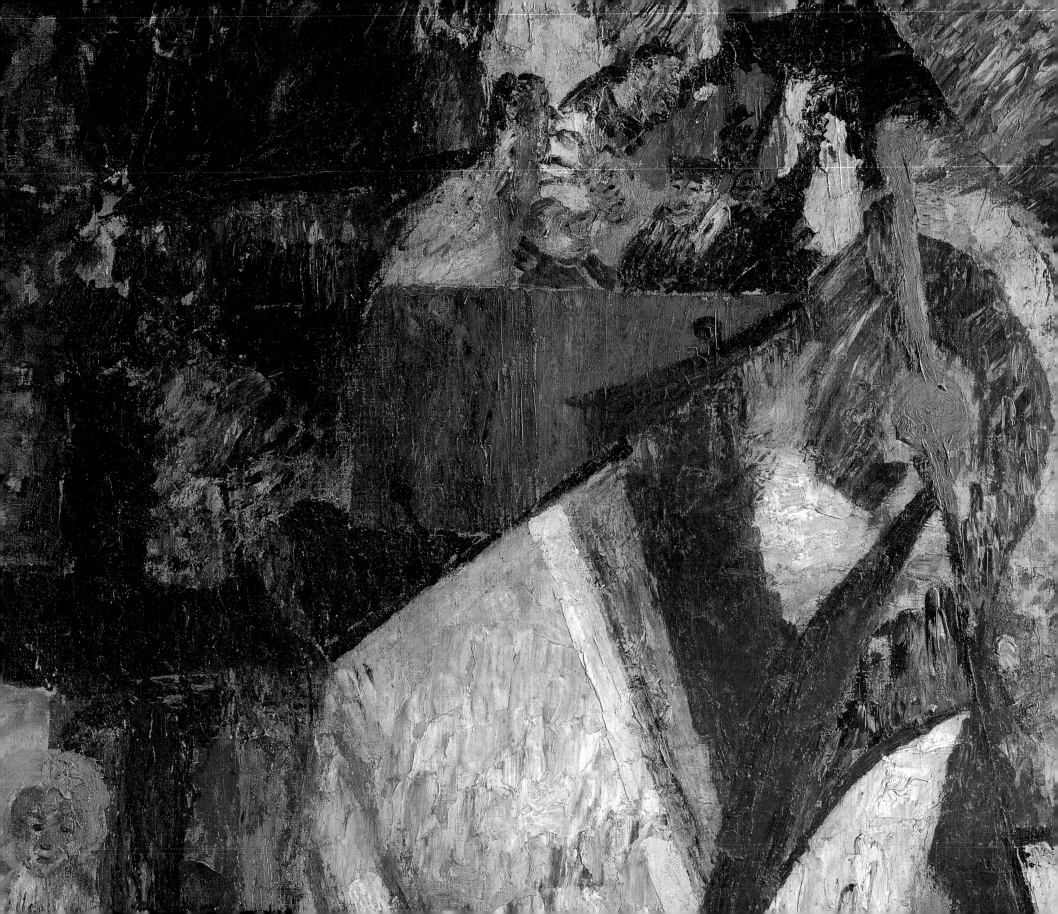

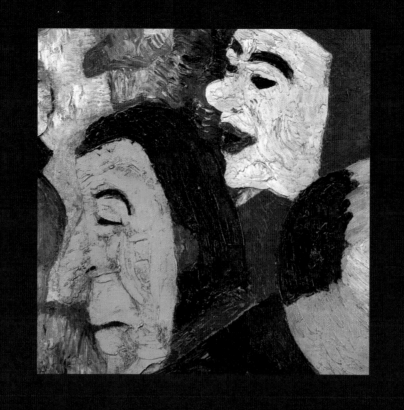

Praise be to Nero's Neptune
The Titanic sails at dawn
Everybody is shouting:
"Which Side Are You On?"
And Ezra Pound and T.S. Eliot
Fighting in the captain's tower
While calypso singers laugh
And fishermen hold flowers
Between the windows of the sea
Where lovely mermaids flow
And nobody has to think too much
About Desolation Row

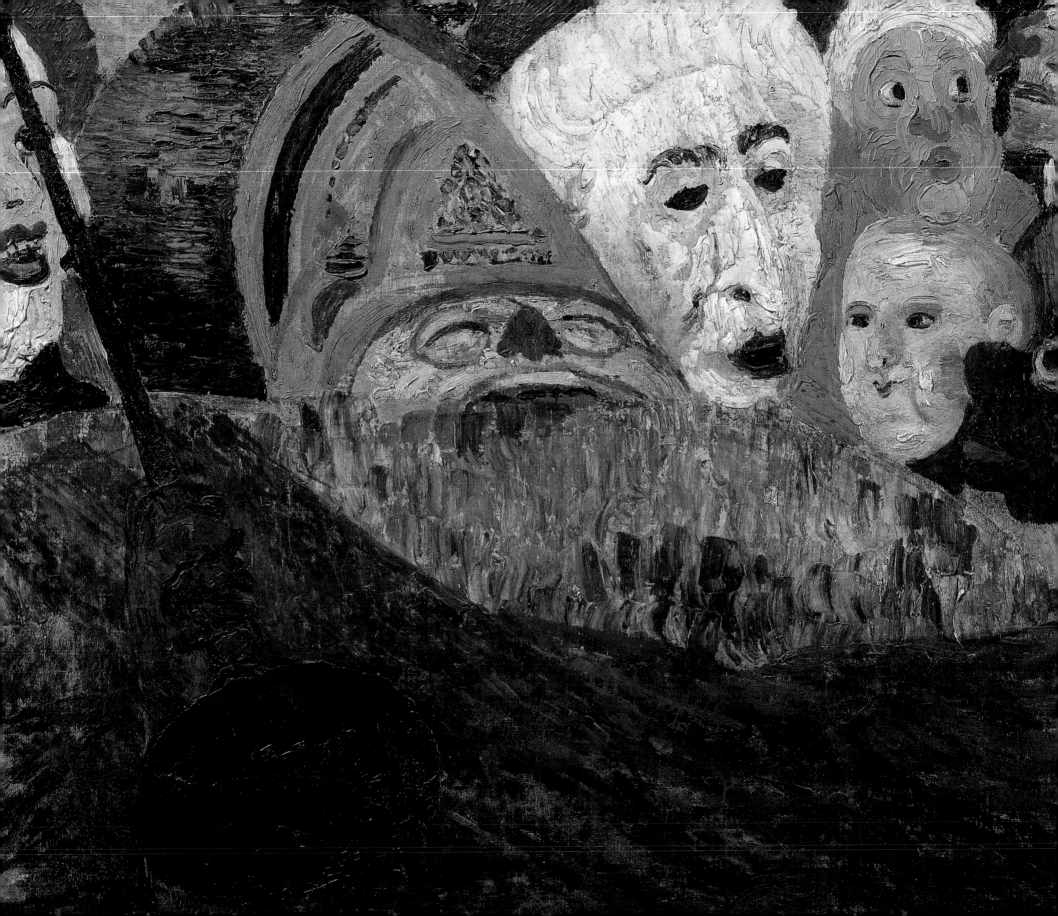

Yes, I received your letter yesterday
(About the time the door knob broke)
When you asked how I was doing
Was that some kind of joke?
All these people that you mention
Yes, I know them, they're quite lame
I had to rearrange their faces
And give them all another name

Right now I can't read too good
Don't send me no more letters no
Not unless you mail them
From Desolation Row

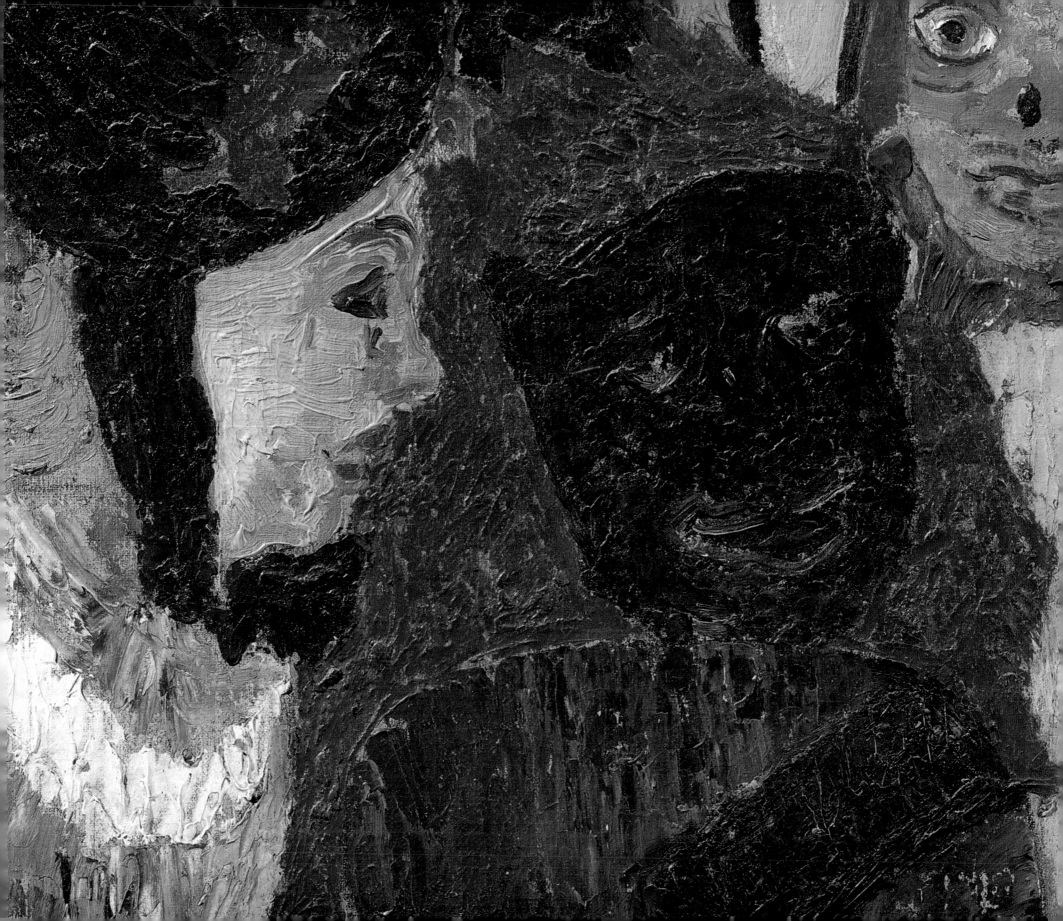

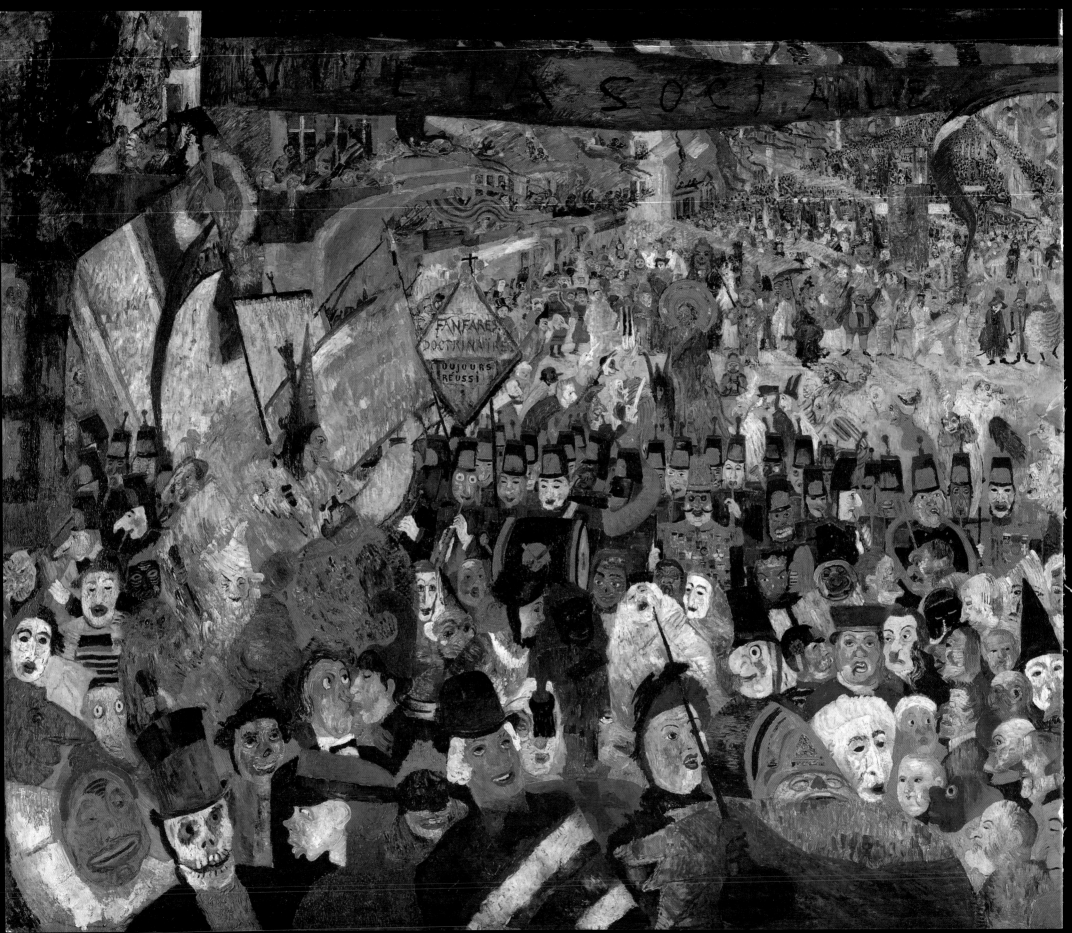

© 1999 The J. Paul Getty Museum

1200 Getty Center Drive

Suite 1000

Los Angeles, California 90049-1687

www.getty.edu/publications

Christopher Hudson, Publisher
Mark Greenberg, Managing Editor

John Harris, Writer and Editor
Markus Brilling, Designer
Elizabeth Zozom, Production Coordinator
Lou Meluso, Photographer

Library of Congress Catalog Card Number: 99-071491

Self-portrait of James Ensor:
ENSOR IN FRONT OF HIS EASEL (detail), 1892. Oil on canvas,
59.5 x 41 cm (23³⁄₈ x 16¹⁄₈ in.). Koninklijk Museum voor
Schone Kunsten, Antwerpen (België), inv. 2809.

James Ensor (Belgian), 1860-1949.
CHRIST'S ENTRY INTO BRUSSELS IN 1889, 1888. Oil on canvas,
252.2 x 430.5 cm (99¹⁄₂ x 169¹⁄₂ in.).
Los Angeles, The J. Paul Getty Museum, 87.PA.96.

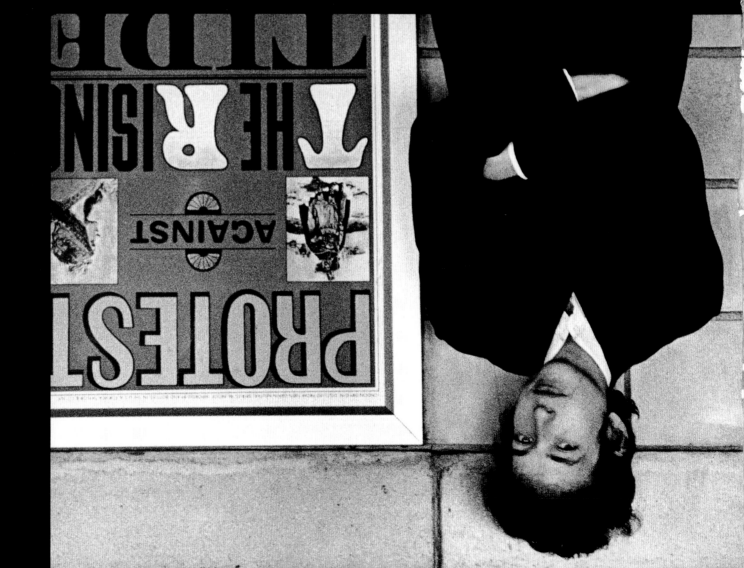

BOB DYLAN

Born in Duluth, Minnesota, in 1941, Bob Dylan has had a remarkable career that has spanned nearly four decades, from his first album, BOB DYLAN, in 1962, to TIME OUT OF MIND, the 1997 album that won the Grammy award for Record of the Year. Some of his other classic albums include THE TIMES THEY ARE A-CHANGIN', BRINGING IT ALL BACK HOME, HIGHWAY 61 REVISITED, BLONDE ON BLONDE, JOHN WESLEY HARDING, BLOOD ON THE TRACKS, THE BASEMENT TAPES, and WORLD GONE WRONG.

From Woody Guthrie, the blues, and early rock'n'roll, Bob Dylan forged an idiom that made popular music a vehicle for personal observation, satire, protest, and meditation. In the words of Bruce Springsteen, "He invented a new way a pop singer could sound, broke through the barriers of what a recording artist could achieve, and changed the face of rock'n'roll forever."

"Desolation Row," from 1965's HIGHWAY 61 REVISITED, contains the kind of apocalyptic, intensely personal imagery that was characteristic of Dylan's music at this time. It is a song he continues to perform, most recently on the MTV UNPLUGGED album of 1996; it also appears on LIVE 1966: THE "ROYAL ALBERT HALL" CONCERT, released in 1998.

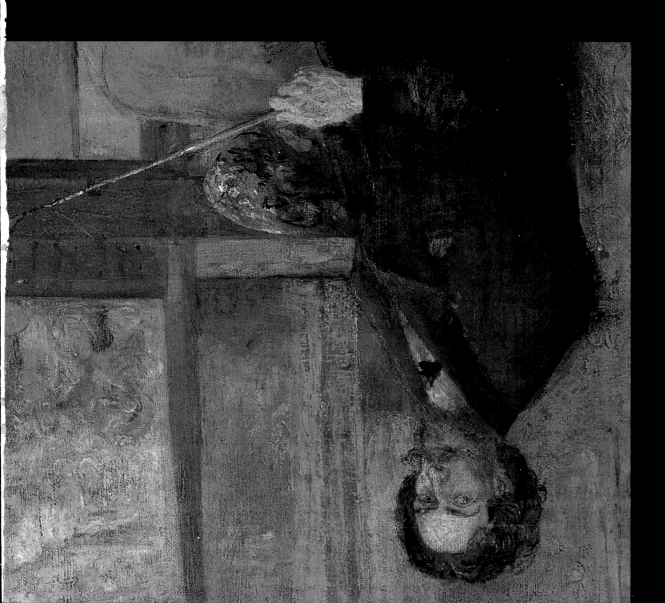

JAMES ENSOR

James Ensor (1860–1949) was born in Ostend, Belgium, where he lived for most of his long life. He studied painting in Brussels and in 1883 joined an avant-garde art movement there known as Les Vingt (The Twenty). The 1880s and 1890s were the great years for Ensor's art. During this time he produced a prodigious amount of work, including most of the paintings and etchings for which he is best known today, among them his masterpiece, CHRIST'S ENTRY INTO BRUSSELS IN 1889 (1888).

CHRIST'S ENTRY, like much of Ensor's mature work, is vibrantly colorful, startling, and mysterious, filled with private, sometimes obsessional, symbols and references. (For example, a green banner in the upper left is marked "XX"—a reference to Les Vingt.) A swarm with waving flags and grotesque carnival masks—a frequent motif in Ensor's work—CHRIST'S ENTRY clearly expresses a satirical vision of contemporary society, as the barely recognizable figure of Jesus (almost lost in the middle of the swirling crowds) enters the Brussels of Ensor's own time. Yet the precise meaning of this immense and powerful painting remains elusive.

Many of Ensor's works can be seen today in his native Belgium, at the Bibliothèque Royale Albert Iᵉʳ and the Musées Royaux des Beaux-Arts in Brussels and at the Musée Royale des Beaux-Arts in Antwerp.

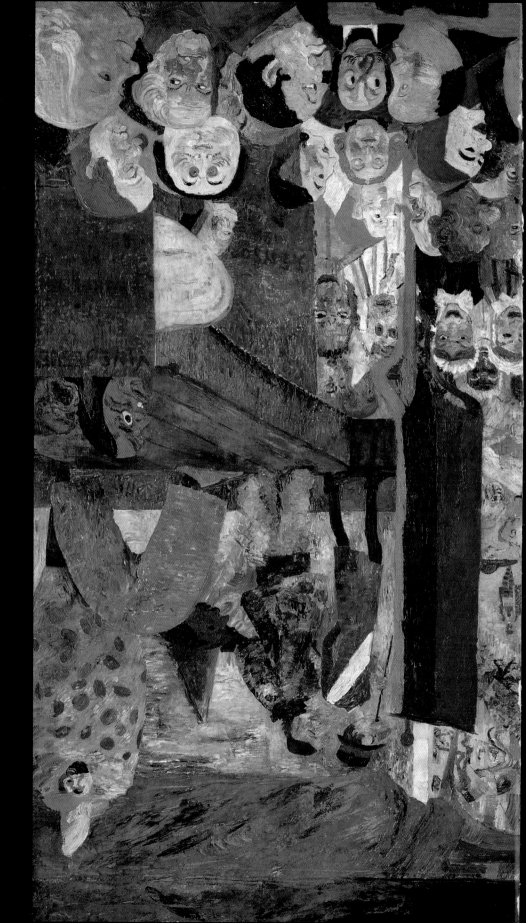

DESOLATION ROW

They're selling postcards of the hanging
They're painting the passports brown
The beauty parlor is filled with sailors
The circus is in town
Here comes the blind commissioner
They've got him in a trance
One hand is tied to the tight-rope walker
The other is in his pants
And the riot squad they're restless
They need somewhere to go
As Lady and I look out tonight
From Desolation Row

Cinderella, she seems so easy
"It takes one to know one," she smiles
And puts her hands in her back pockets
Bette Davis style
And in comes Romeo, he's moaning
"You Belong to Me I Believe"
And someone says, "You're in the wrong place, my friend
You better leave"
And the only sound that's left
After the ambulances go
Is Cinderella sweeping up
On Desolation Row

Now the moon is almost hidden
The stars are beginning to hide
The fortunetelling lady
Has even taken all her things inside
All except for Cain and Abel
And the hunchback of Notre Dame
Everybody is making love
Or else expecting rain
And the Good Samaritan, he's dressing
He's getting ready for the show
He's going to the carnival tonight
On Desolation Row

Now Ophelia, she's 'neath the window
For her I feel so afraid
On her twenty-second birthday
She already is an old maid
To her, death is quite romantic
She wears an iron vest
Her profession's her religion
Her sin is her lifelessness
And though her eyes are fixed upon
Noah's great rainbow
She spends her time peeking
Into Desolation Row

Einstein, disguised as Robin Hood
With his memories in a trunk
Passed this way an hour ago
With his friend, a jealous monk
He looked so immaculately frightful
As he bummed a cigarette
Then he went off sniffing drainpipes
And reciting the alphabet
Now you would not think to look at him
But he was famous long ago
For playing the electric violin
On Desolation Row

Dr. Filth, he keeps his world
Inside of a leather cup
But all his sexless patients
They're trying to blow it up
Now his nurse, some local loser
She's in charge of the cyanide hole
And she also keeps the cards that read
"Have Mercy on His Soul"
They all play on penny whistles
You can hear them blow
If you lean your head out far enough
From Desolation Row

Across the street they've nailed the curtains
They're getting ready for the feast
The Phantom of the Opera
A perfect image of a priest
They're spoonfeeding Casanova
To get him to feel more assured
Then they'll kill him with self-confidence
After poisoning him with words
And the Phantom's shouting to skinny girls
"Get Outa Here If You Don't Know
Casanova is just being punished for going
To Desolation Row"

Now at midnight all the agents
And the superhuman crew
Come out and round up everyone
That knows more than they do
Then they bring them to the factory
Where the heart-attack machine
Is strapped across their shoulders
And then the kerosene
Is brought down from the castles
By insurance men who go
Check to see that nobody is escaping
To Desolation Row

Praise be to Nero's Neptune
The Titanic sails at dawn
And everybody's shouting
"Which Side Are You On?"
And Ezra Pound and T. S. Eliot
Fighting in the captain's tower
While calypso singers laugh at them
And fishermen hold flowers
Between the windows of the sea
Where lovely mermaids flow
And nobody has to think too much
About Desolation Row

Yes, I received your letter yesterday
(About the time the door knob broke)
When you asked how I was doing
Was that some kind of joke?
All these people that you mention
Yes, I know them, they're quite lame
I had to rearrange their faces
And give them all another name
Right now I can't read too good
Don't send me no more letters no
Not unless you mail them
From Desolation Row